Adult Coloring Book
FLOWERS FROM THE MYSTERY LAKE

by
Bambang Wisudyantoro

Find the secret garden behind the mysterious lake of unknown forest.
You have to across the lake, passing the jungle and across the desaert to find it.
The Secret Garden is lot of various flowers.
But to find those garden is need the little try and chalenges.
Enjoy the adventure and keep color it.

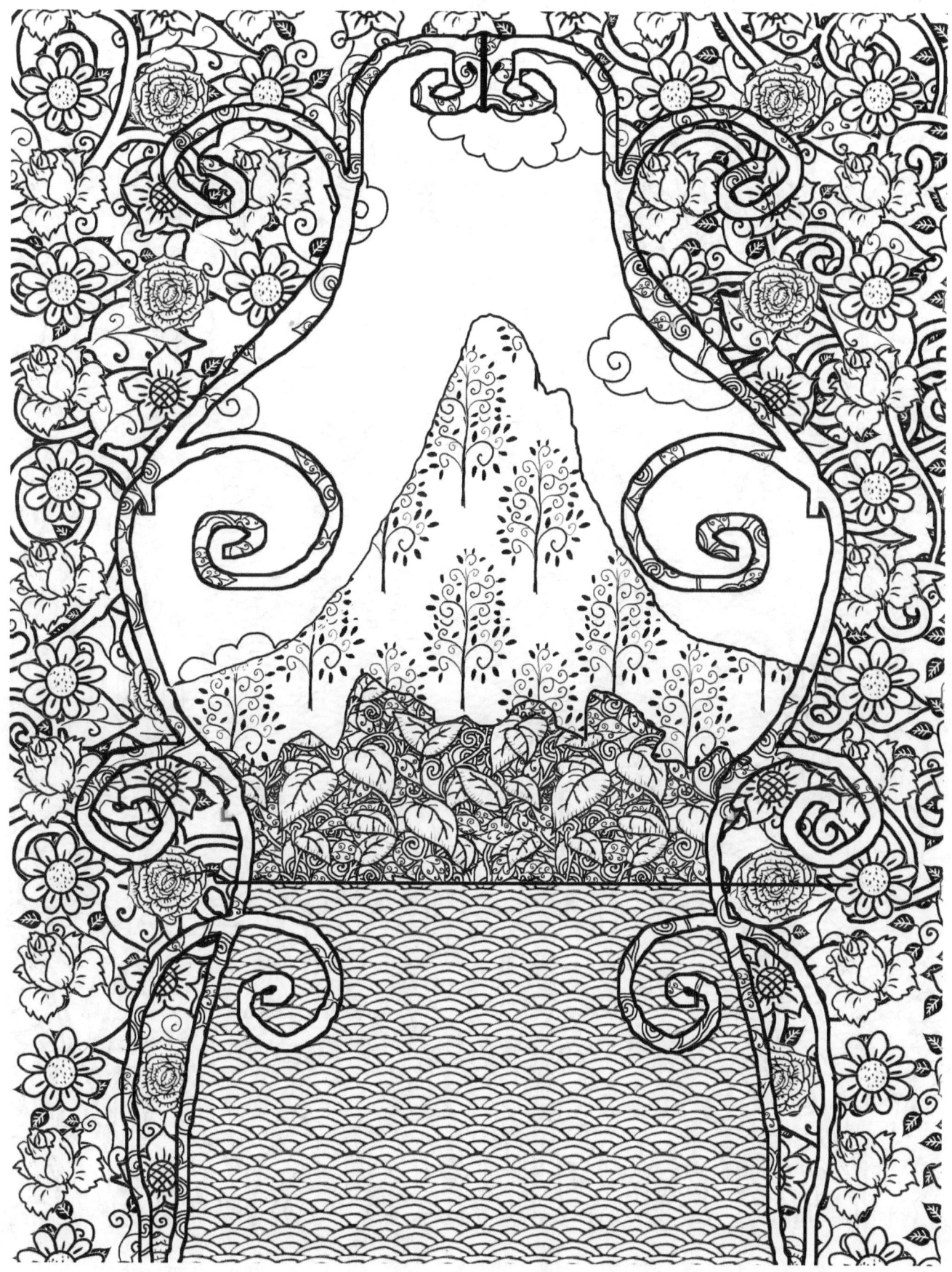

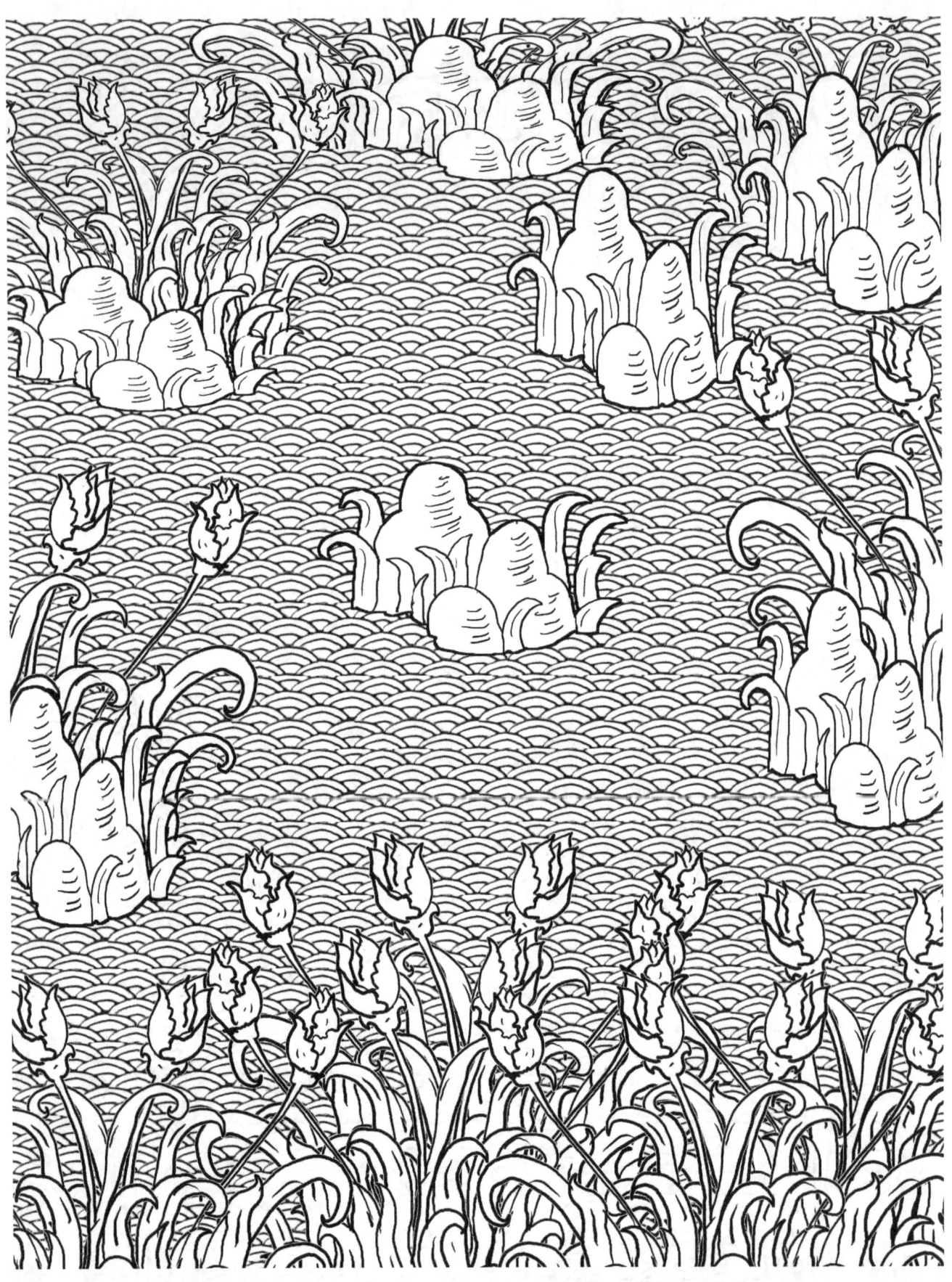

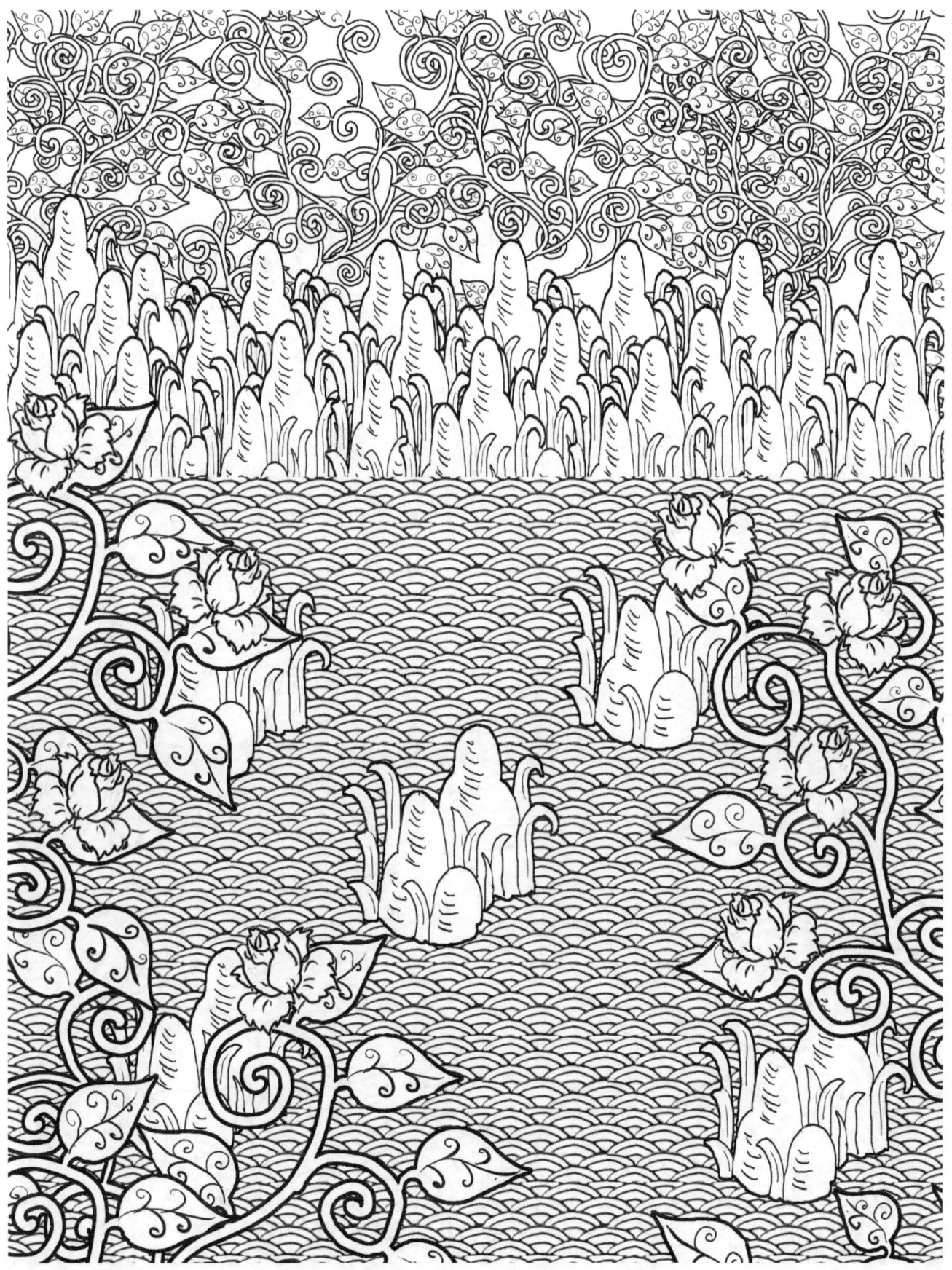

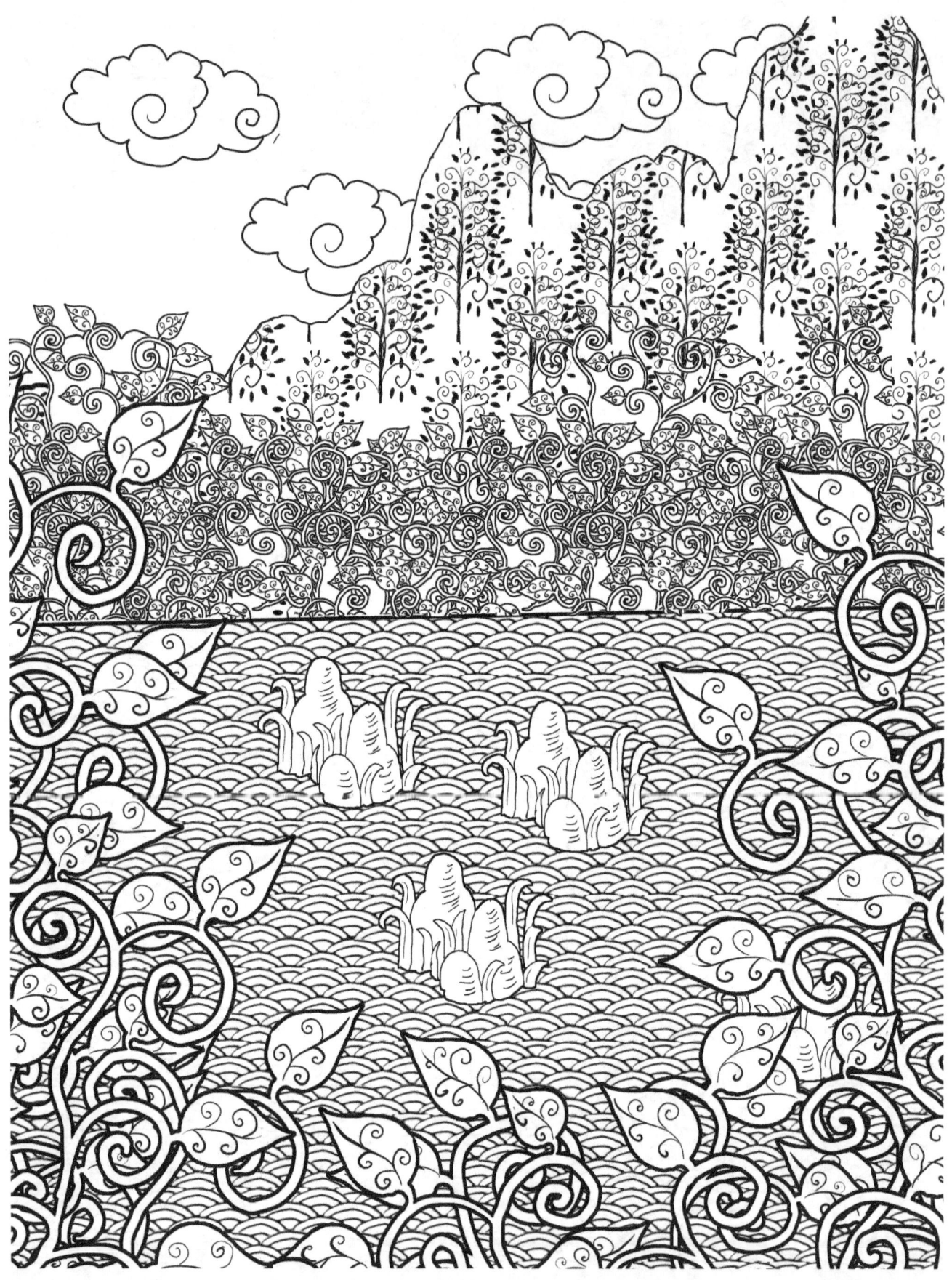

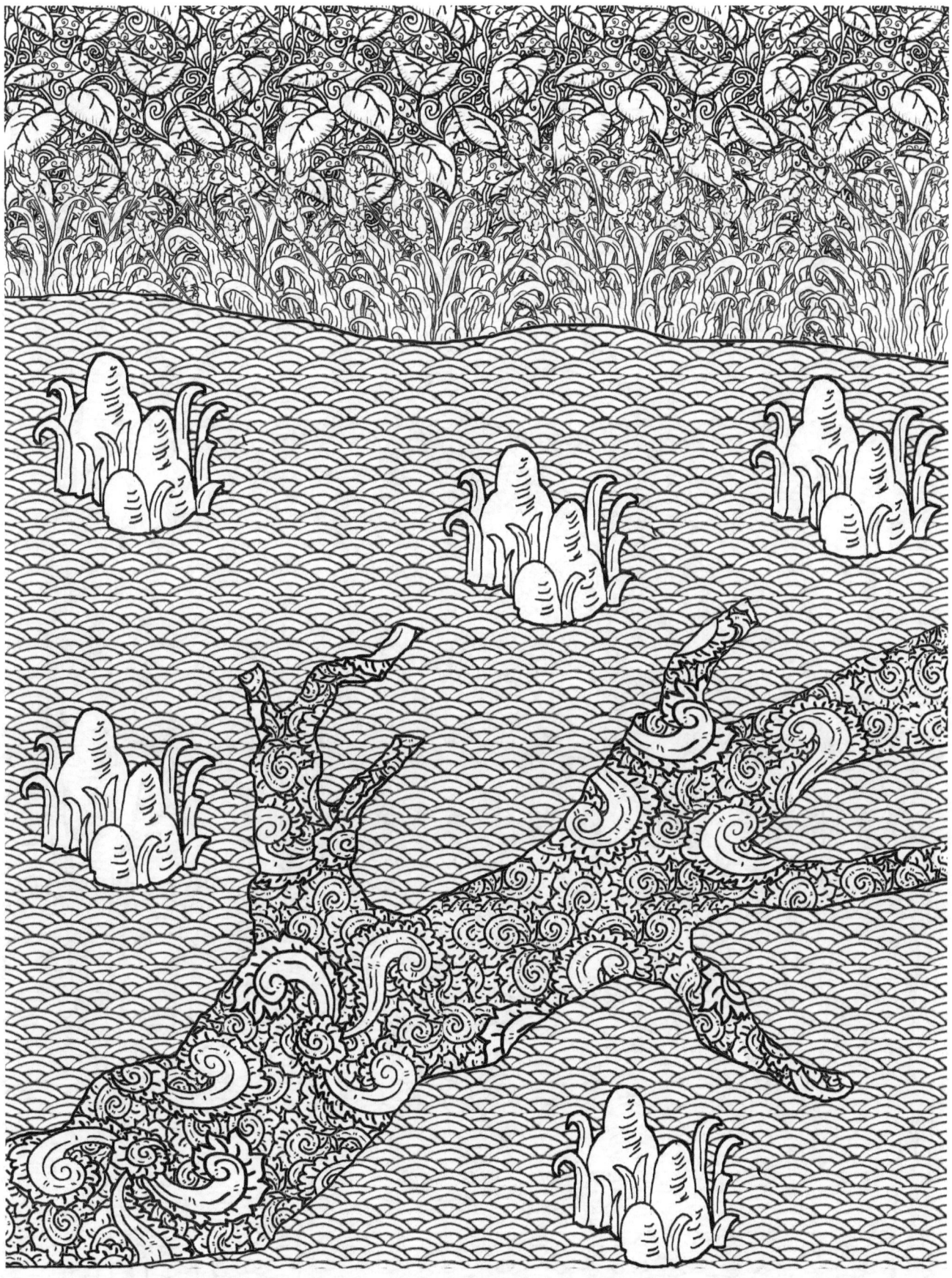

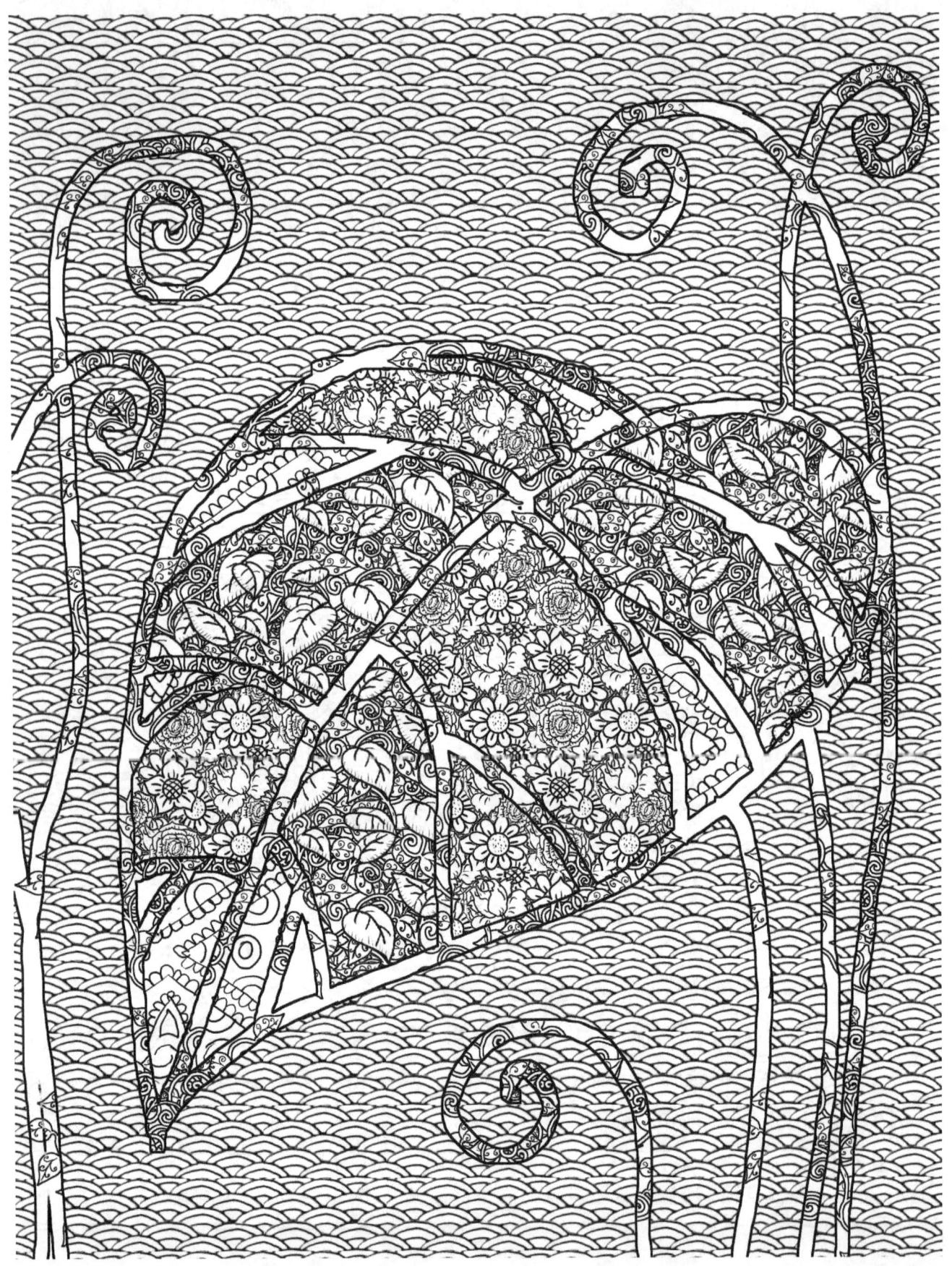

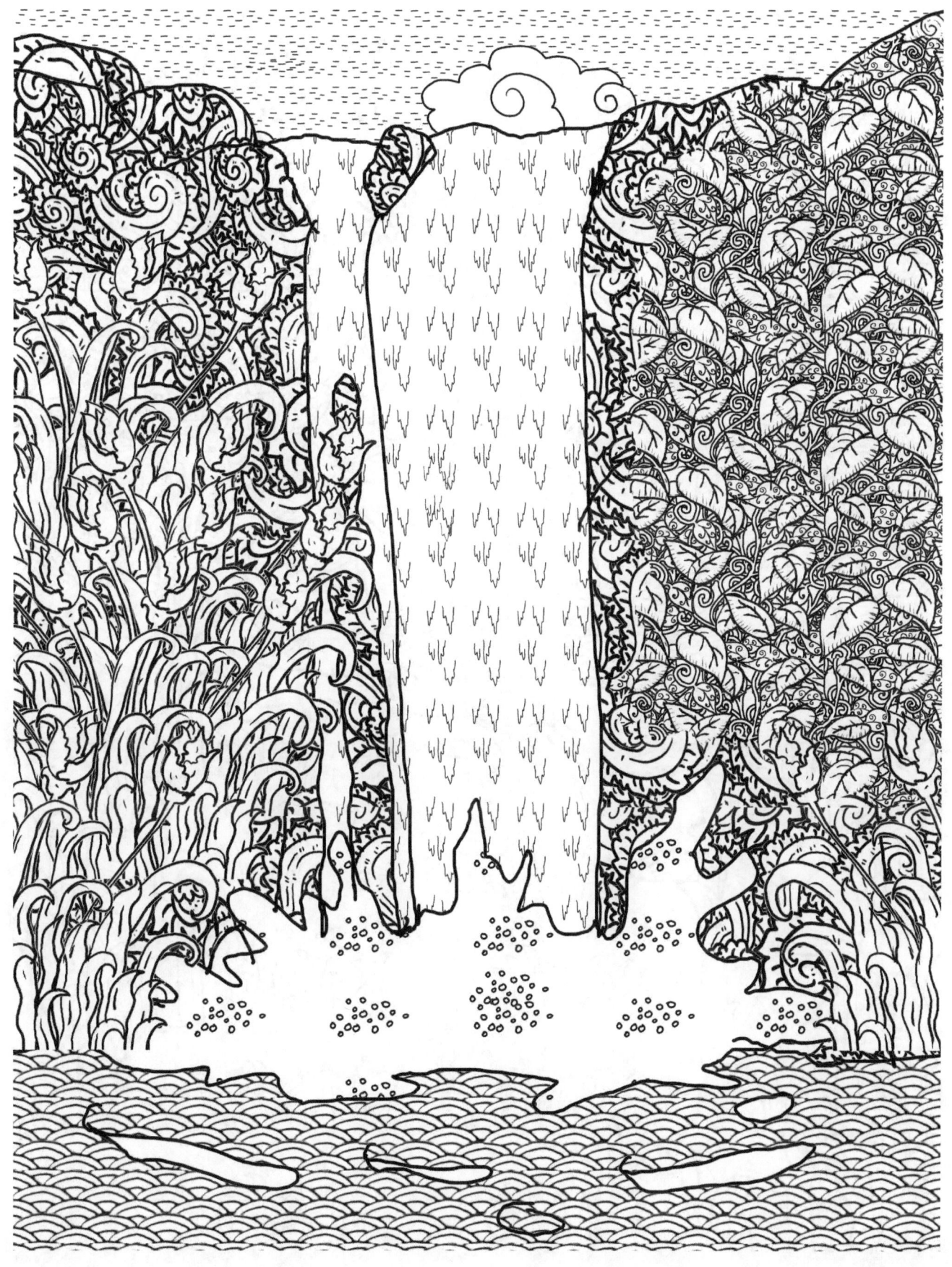

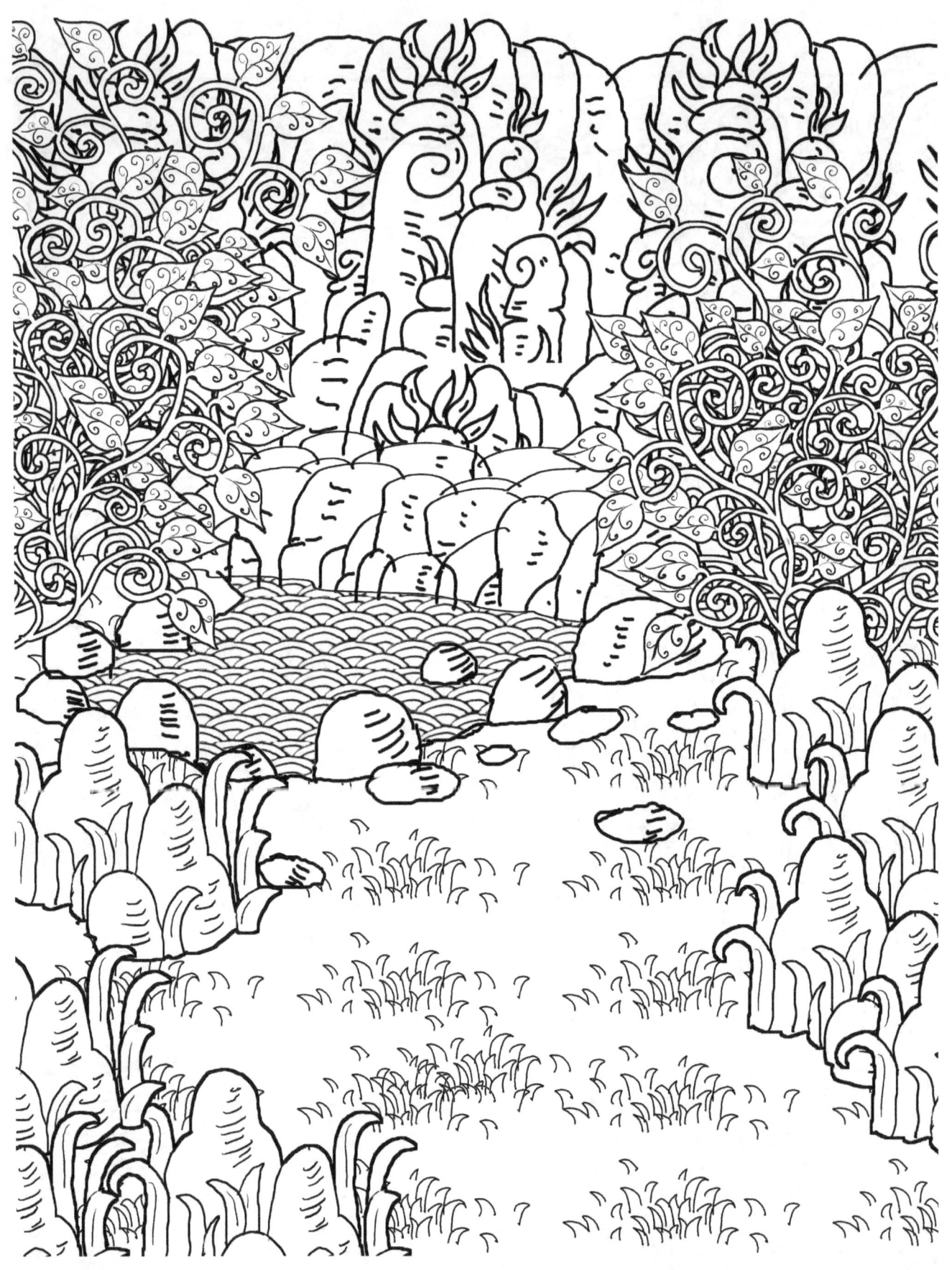

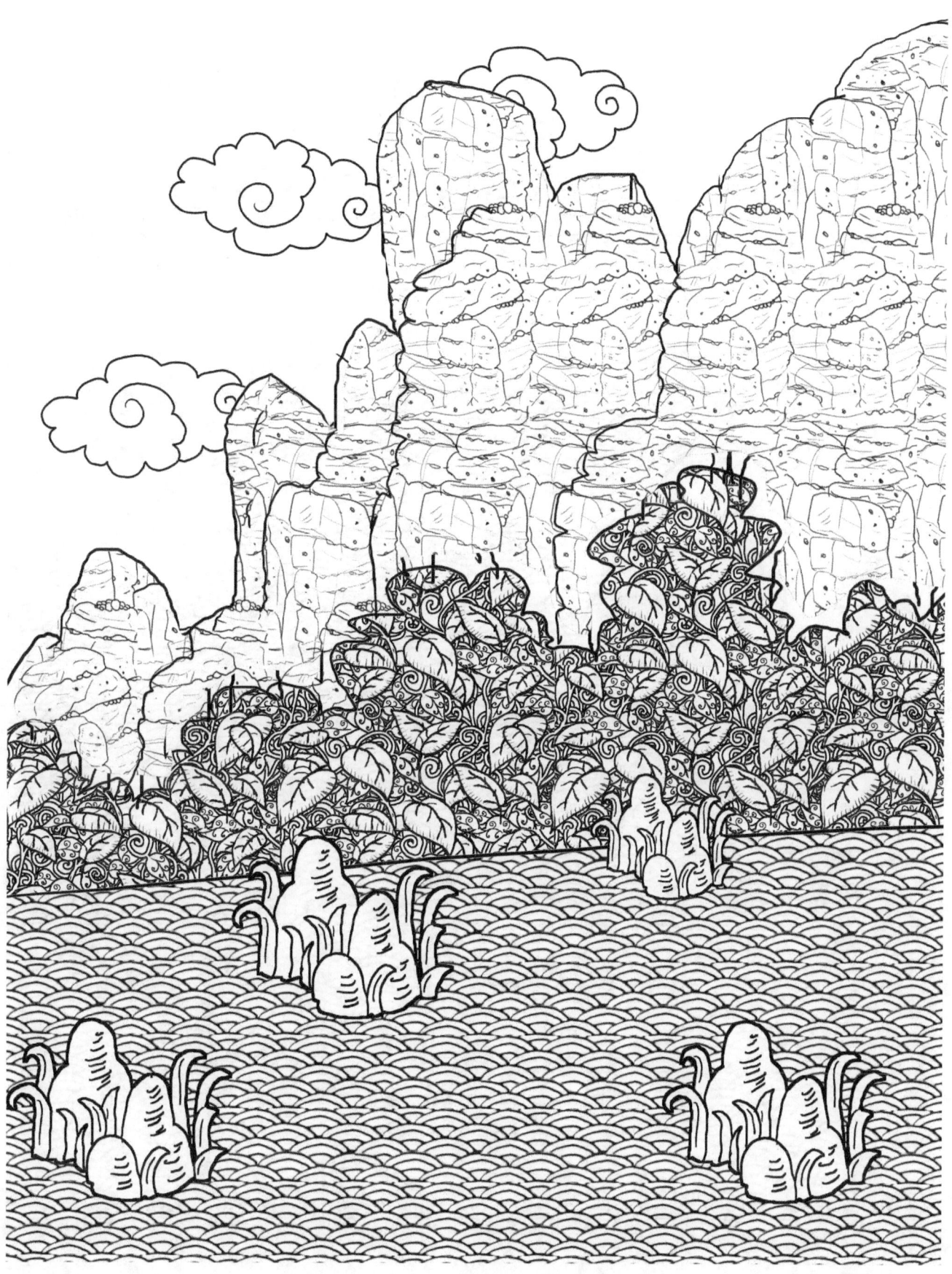

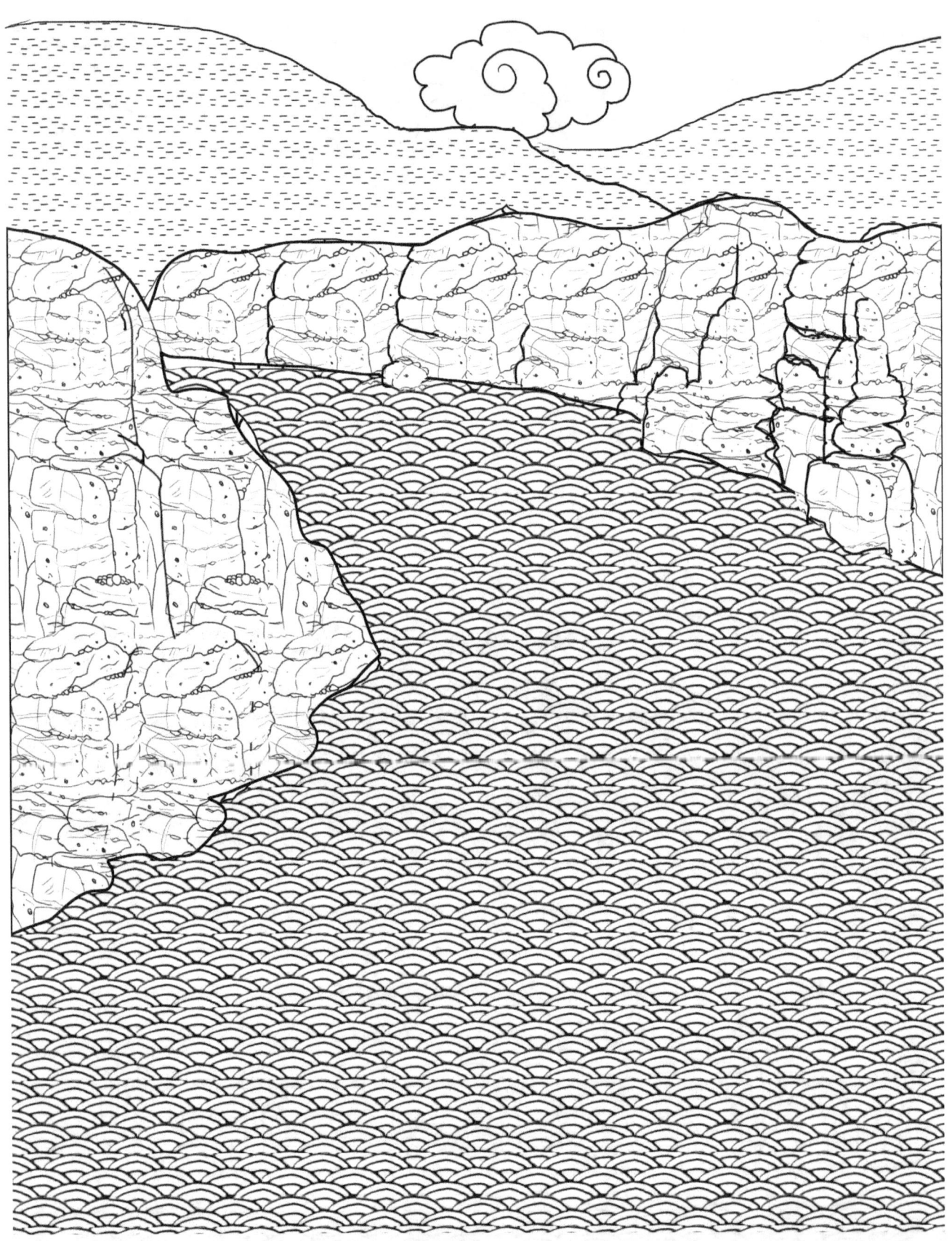

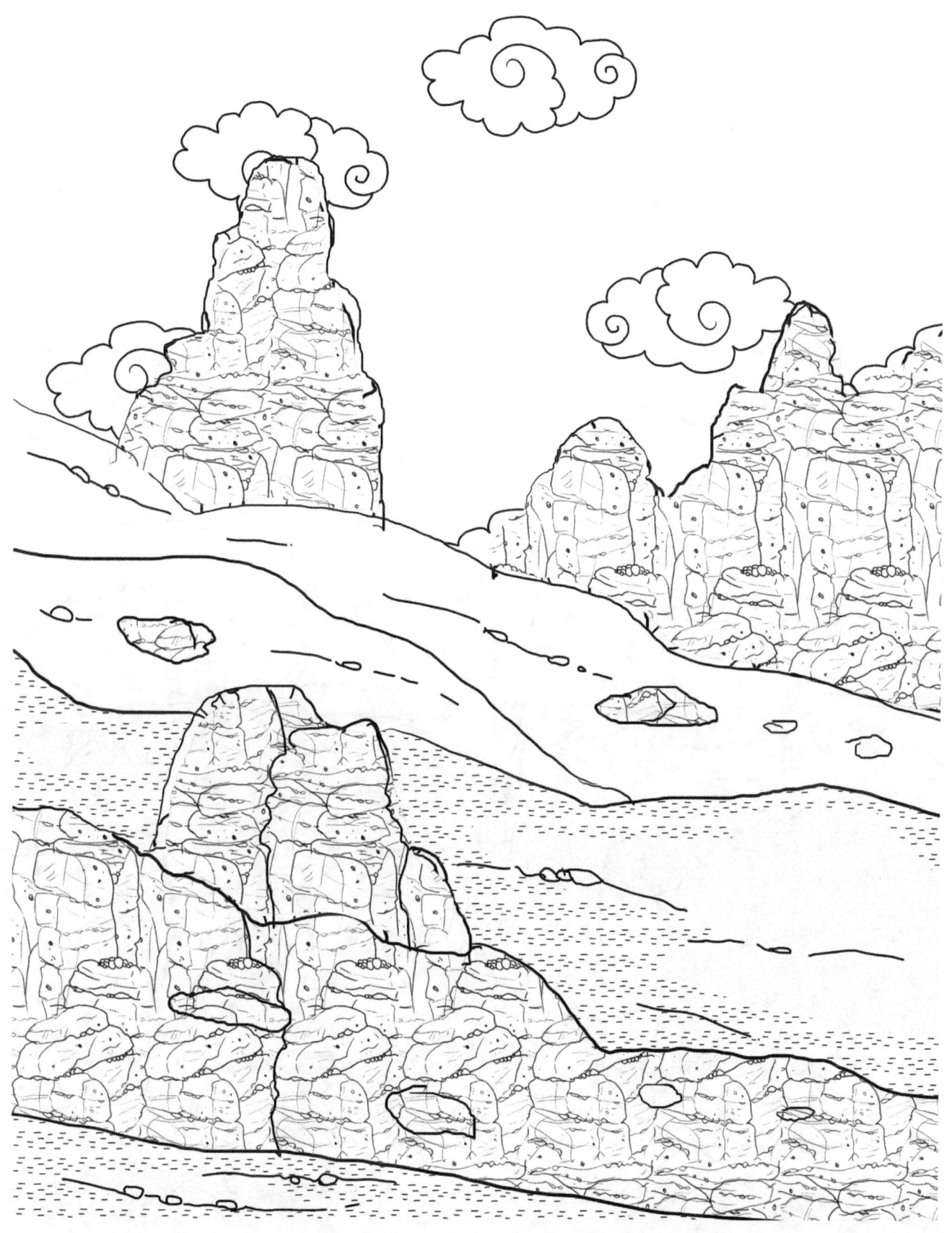

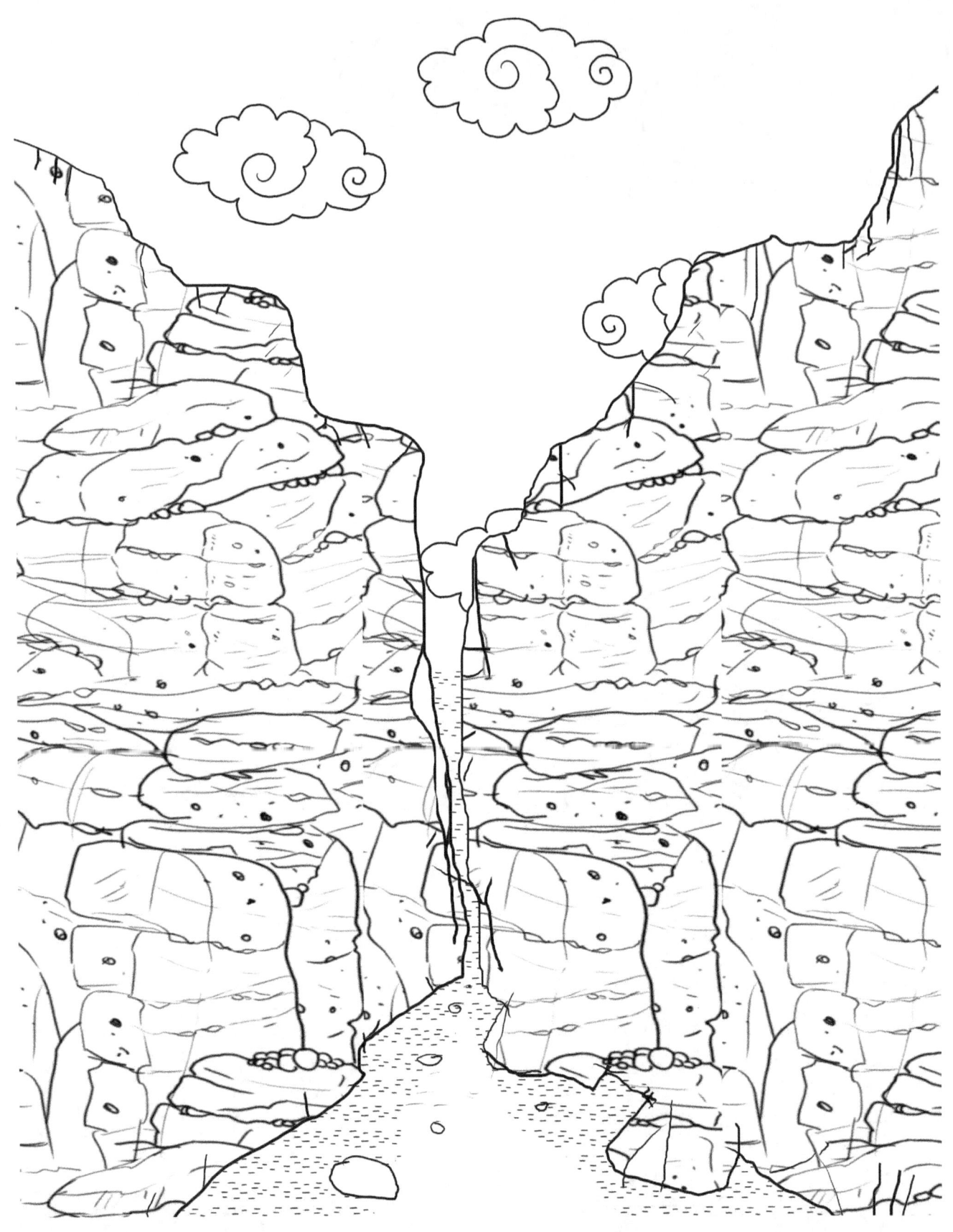

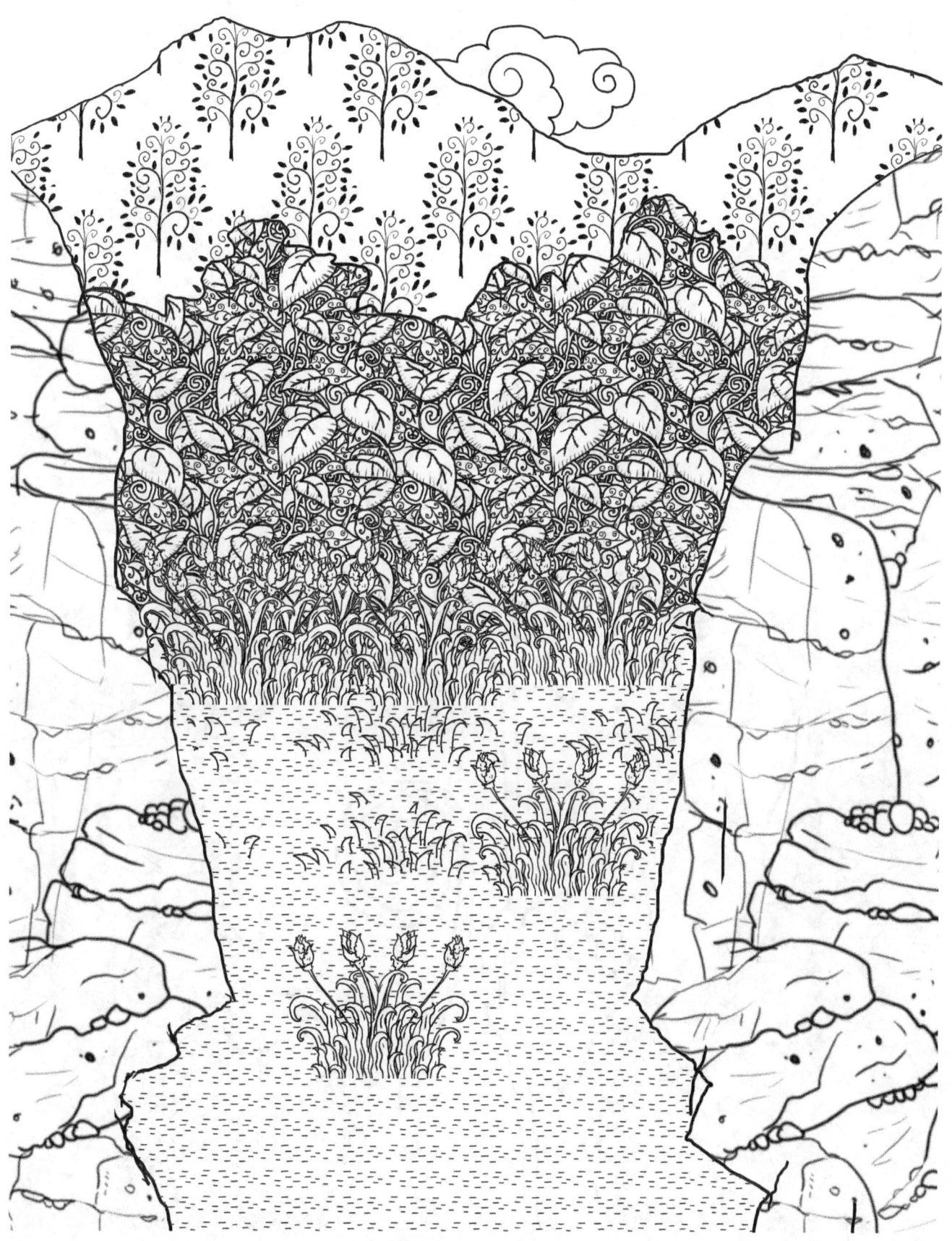

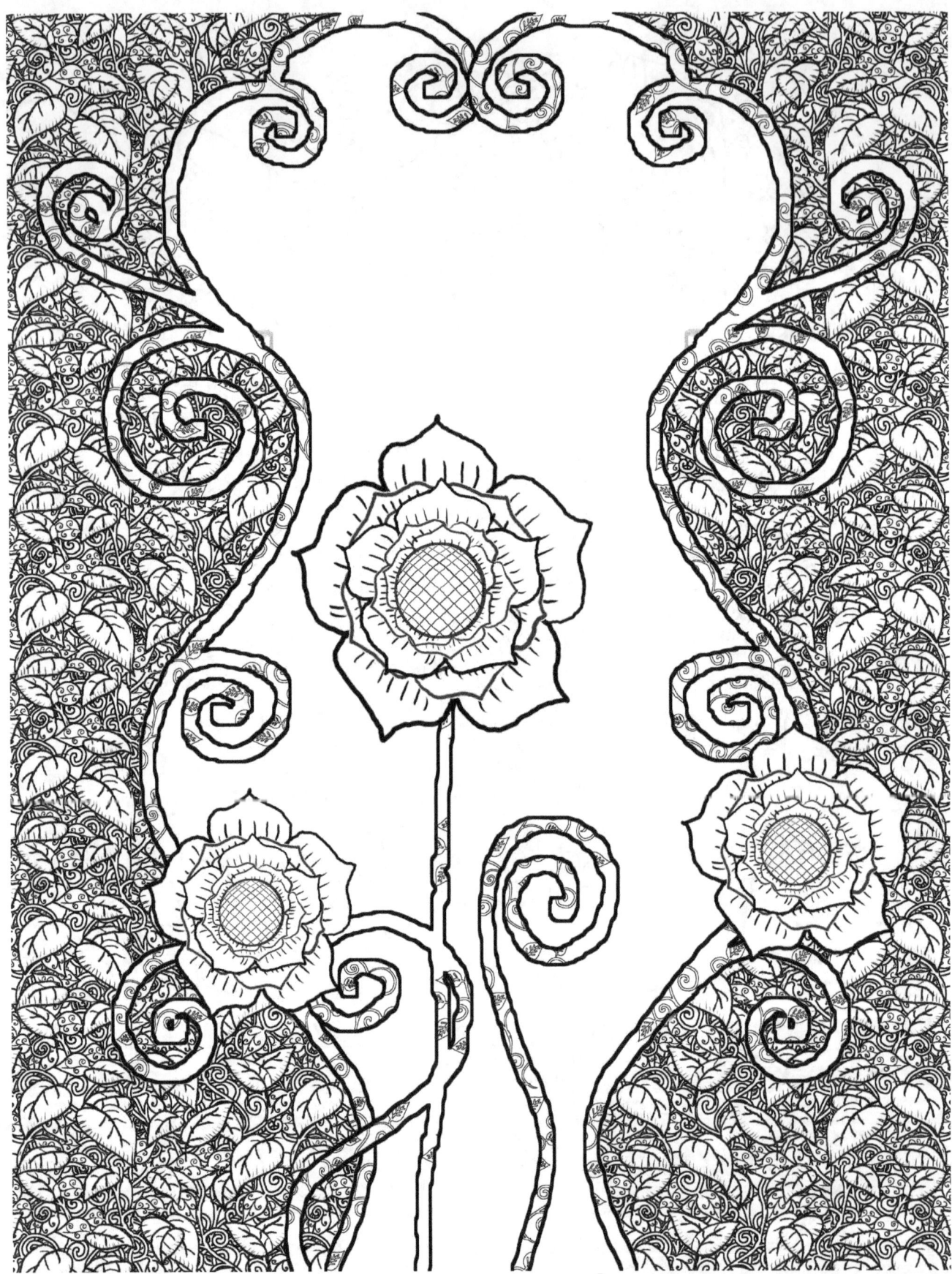

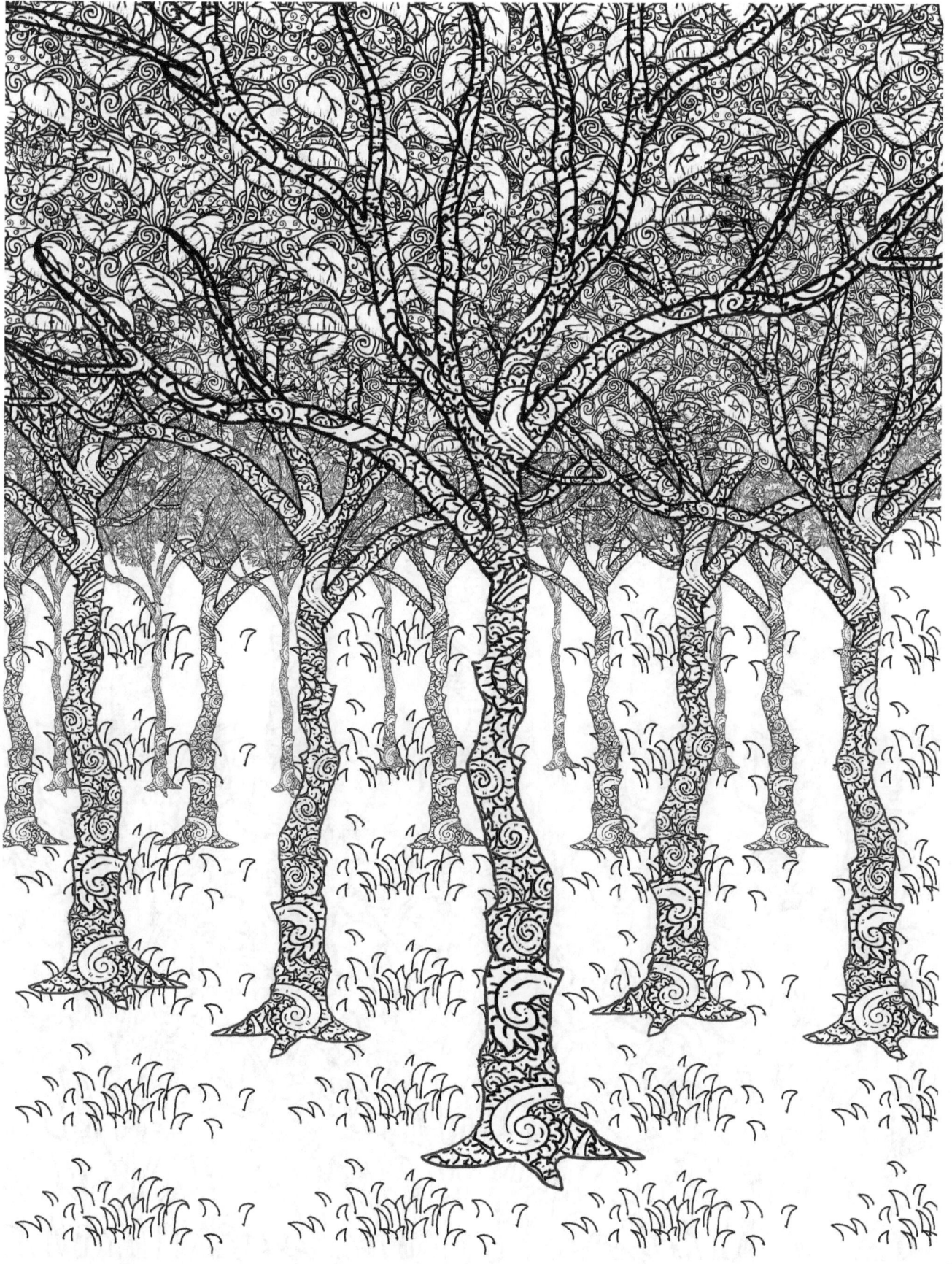

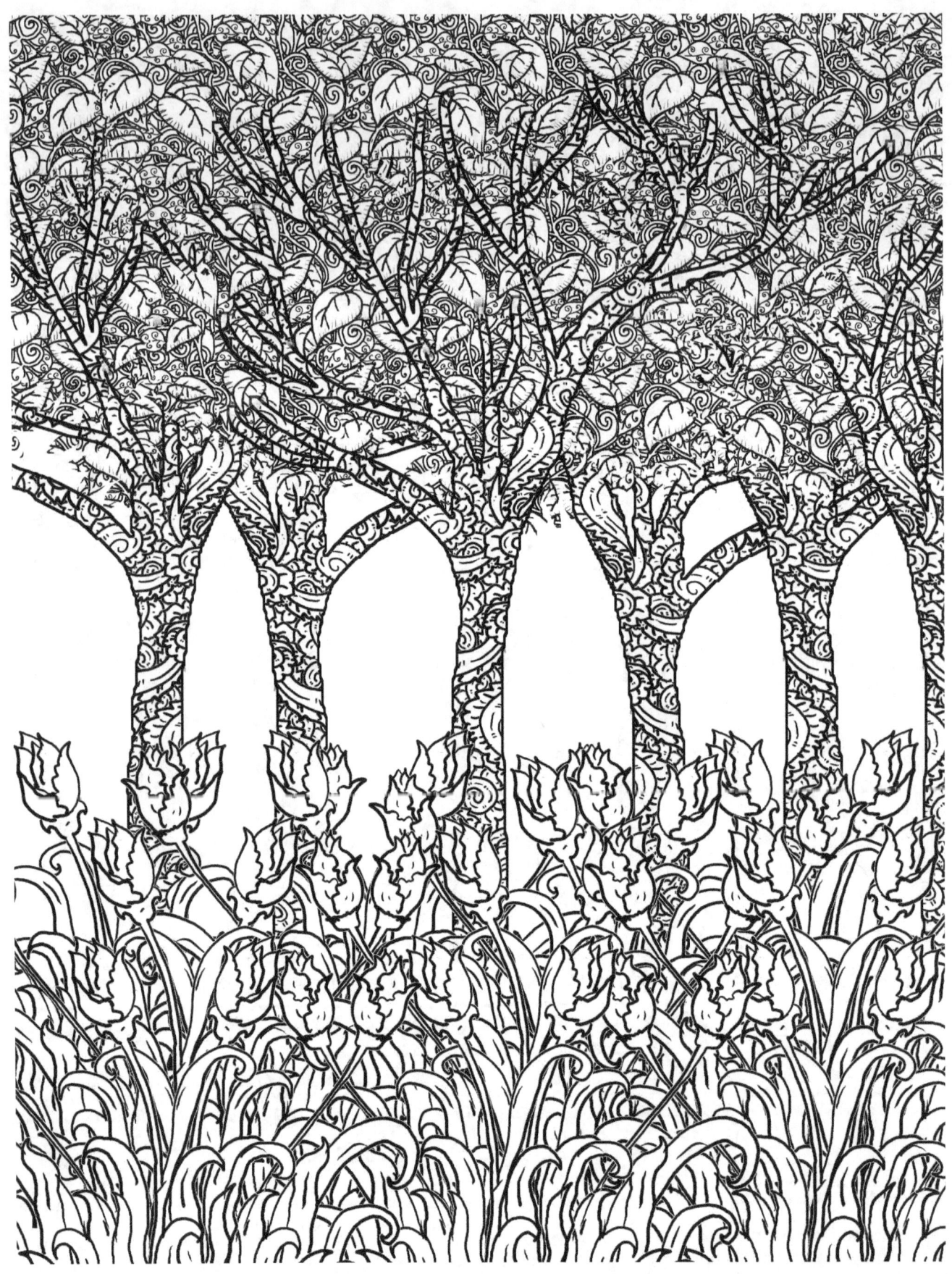

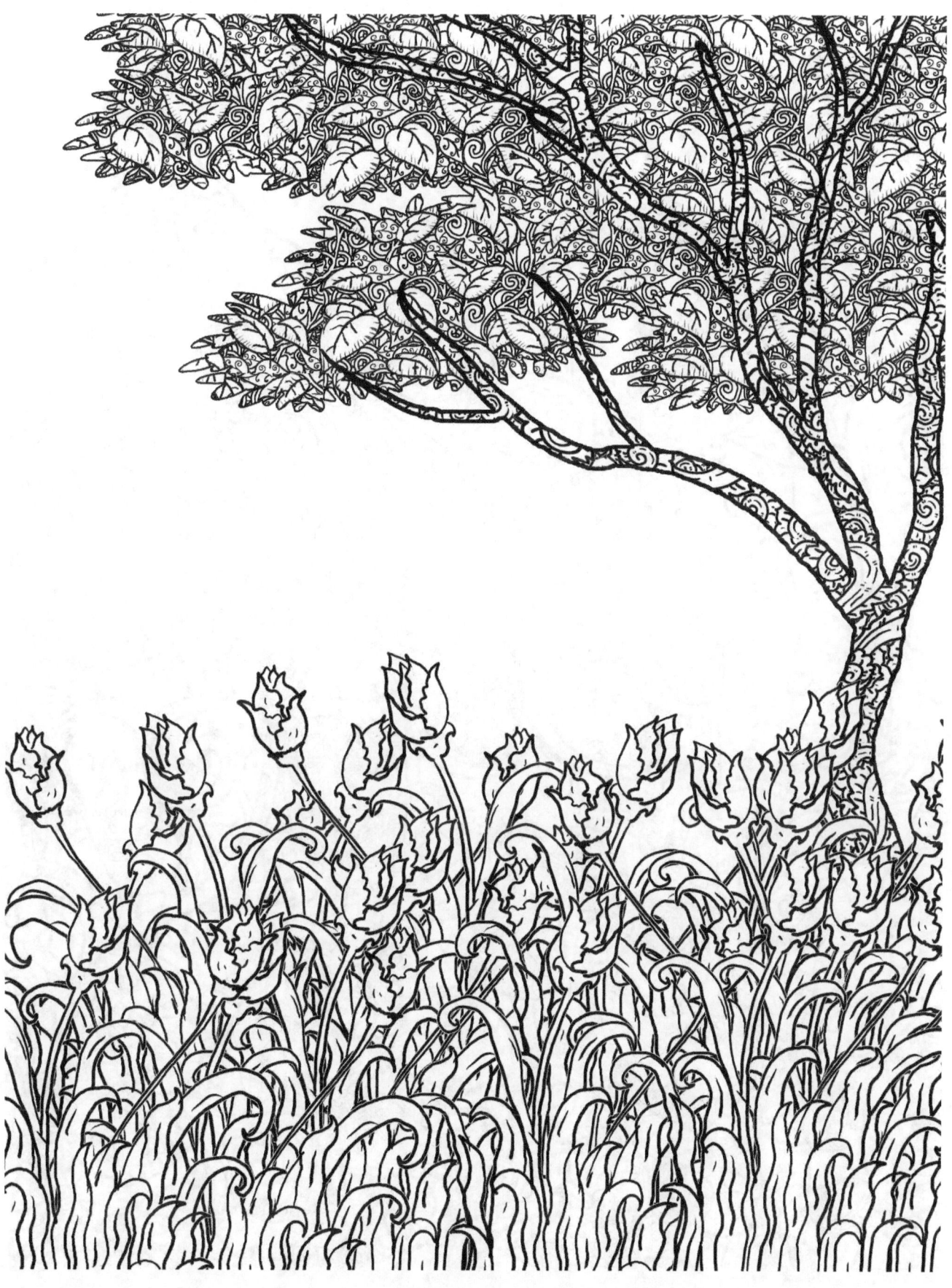

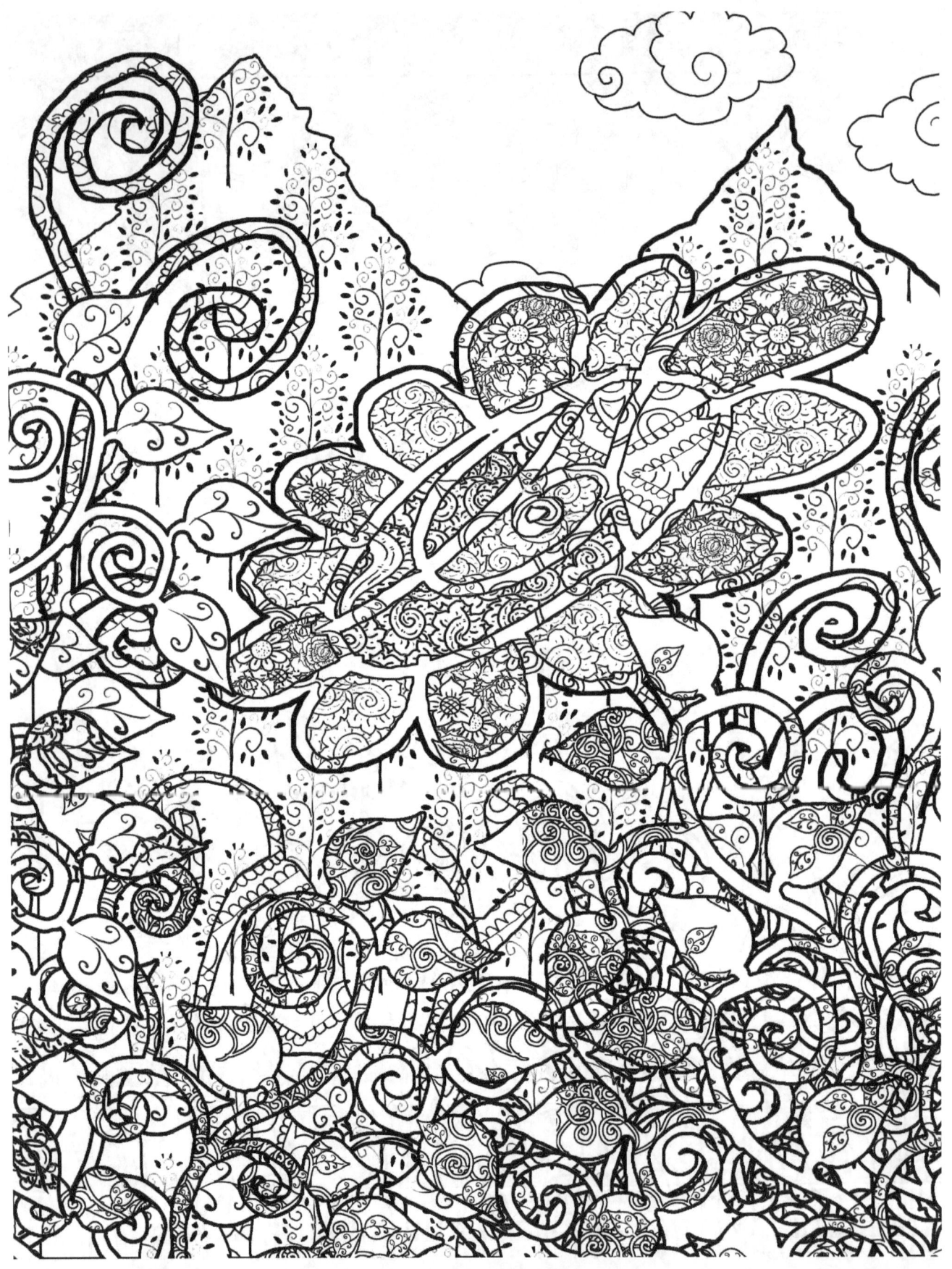

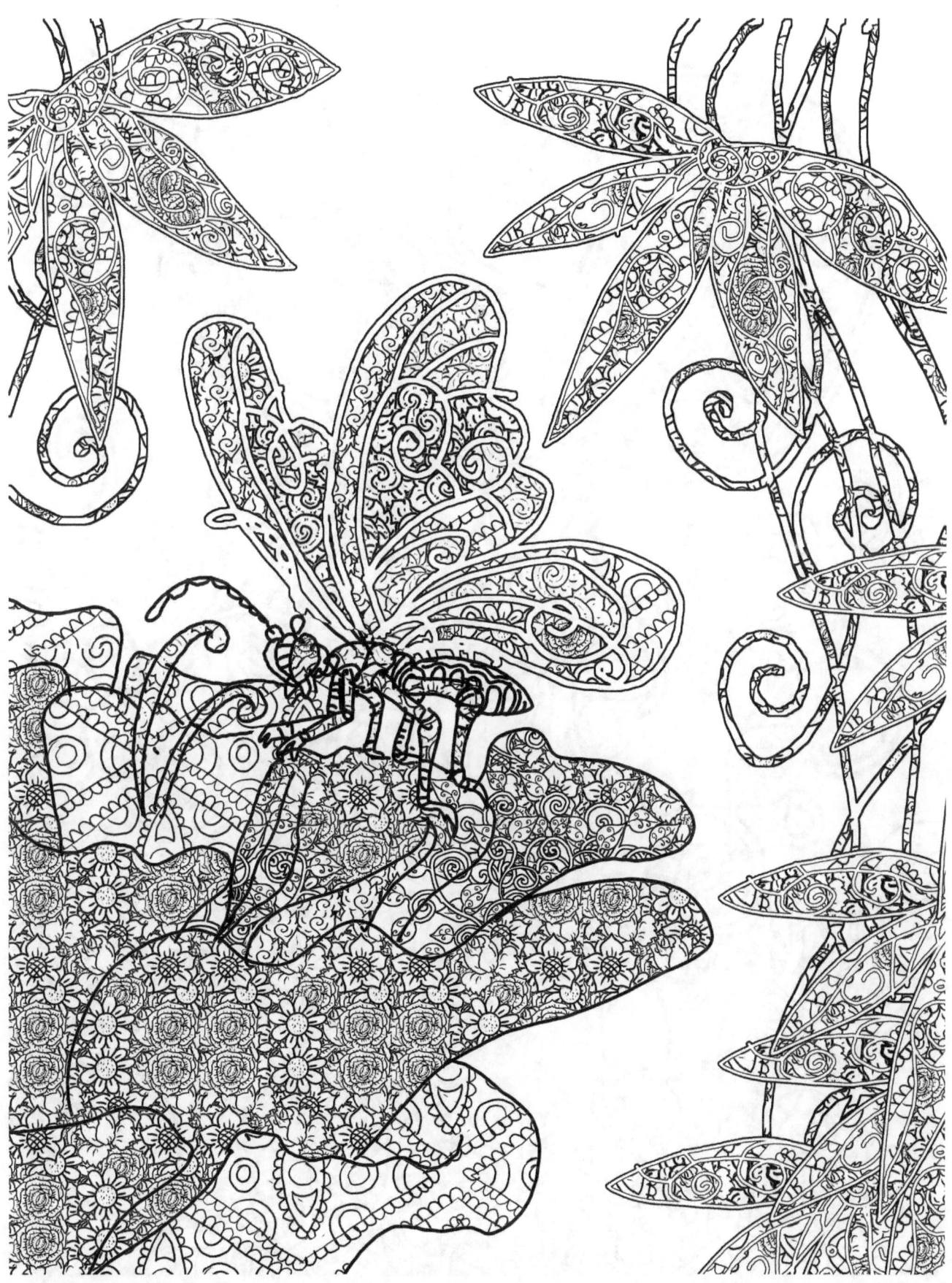

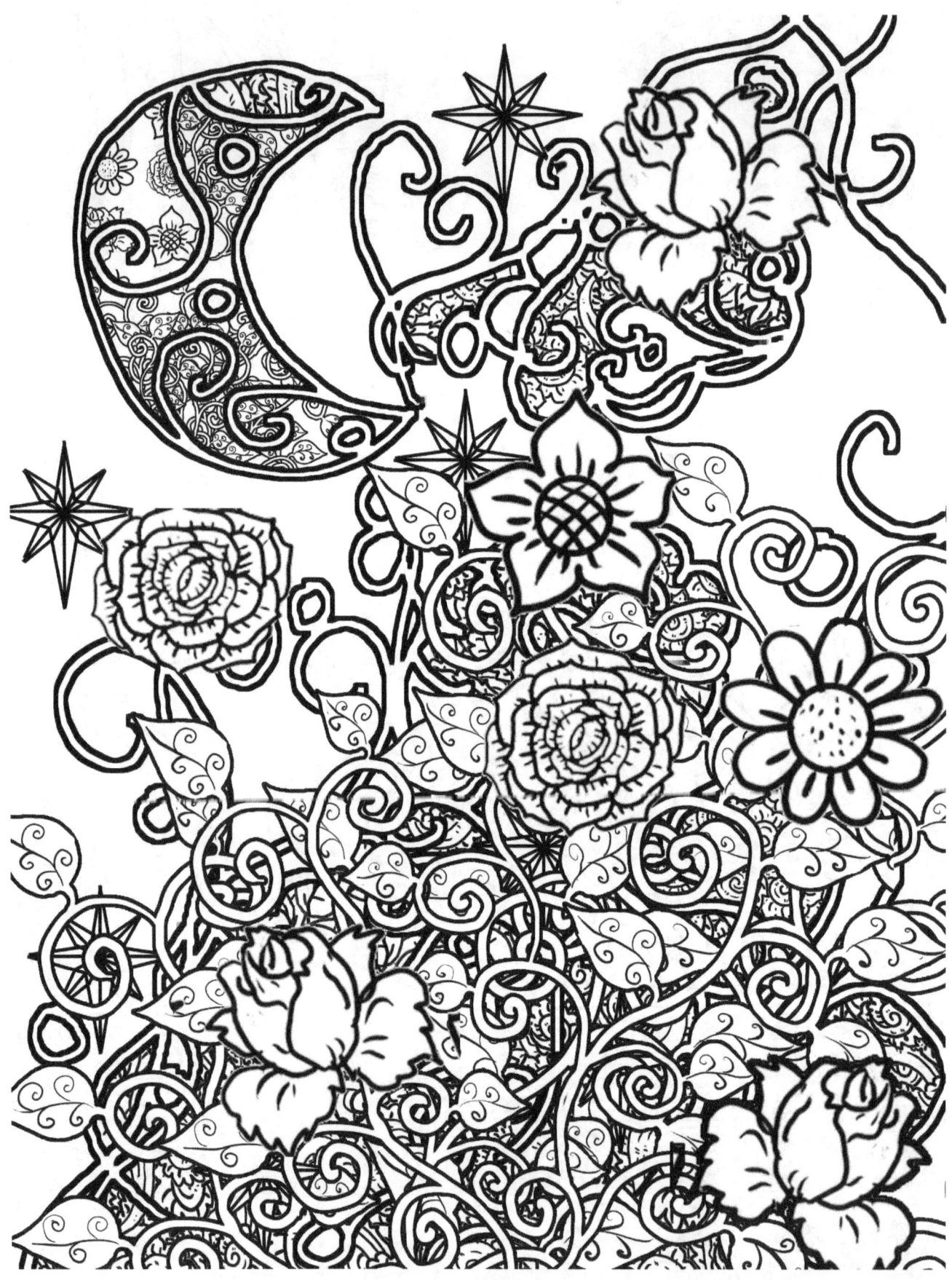

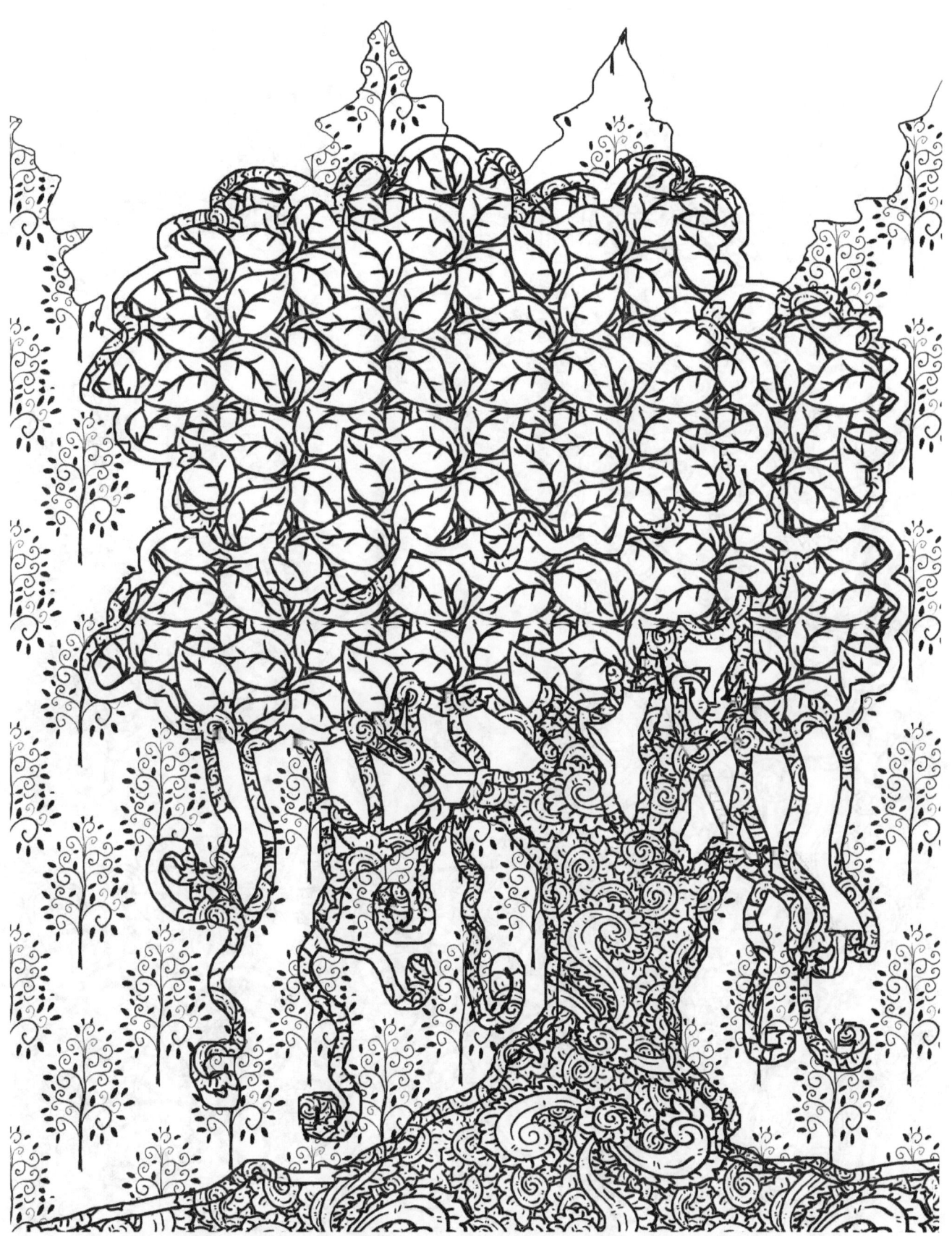

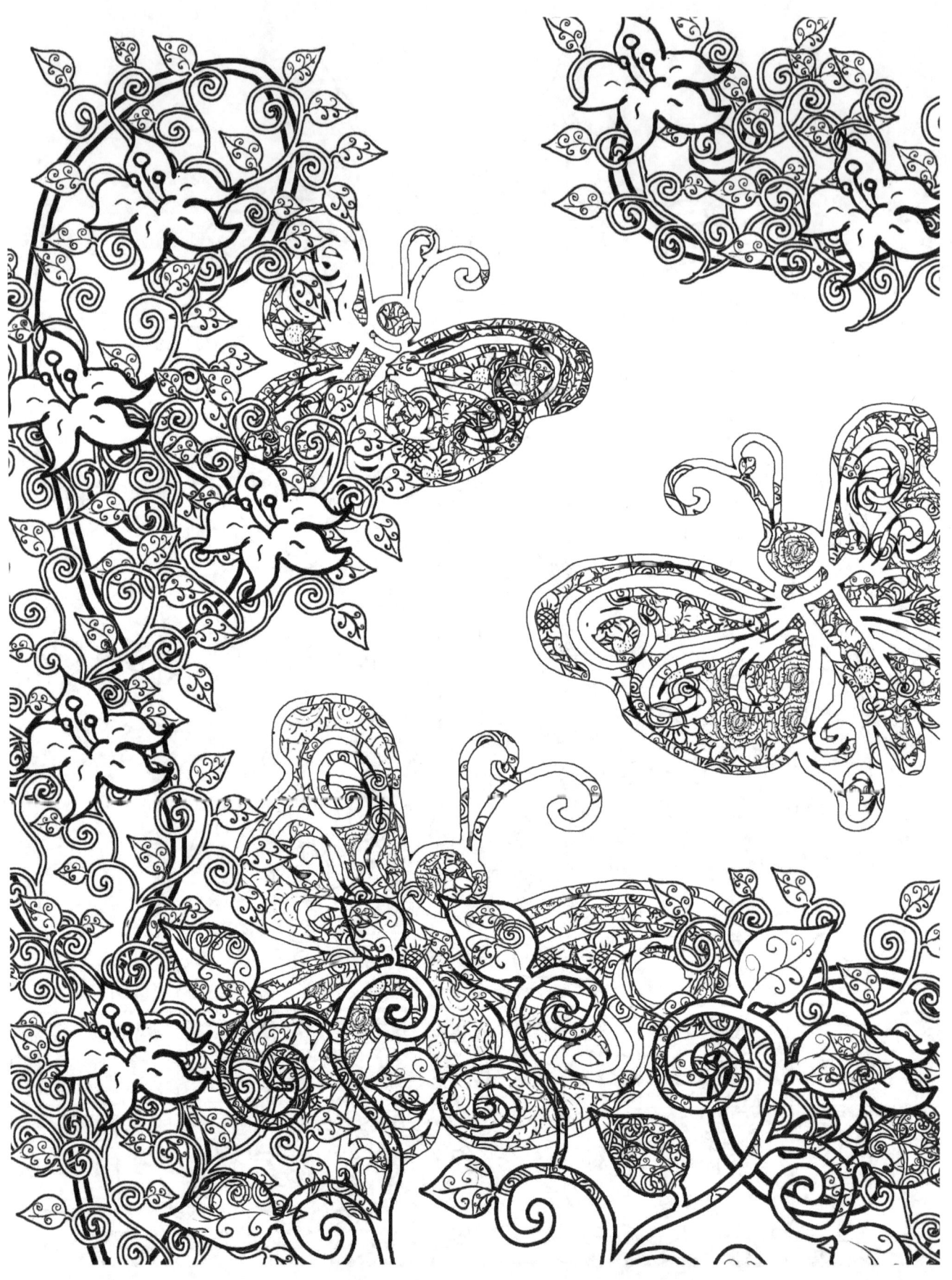

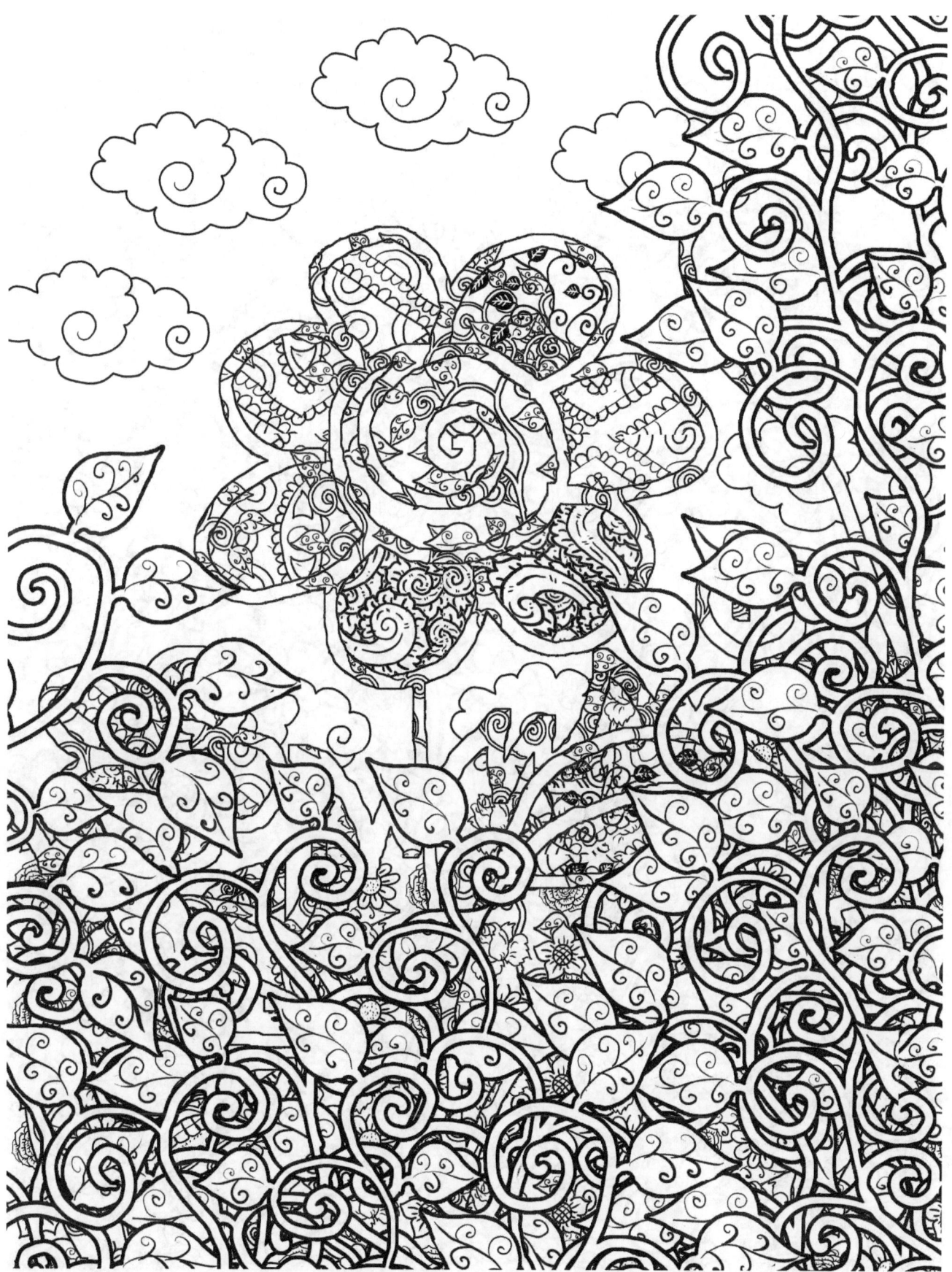

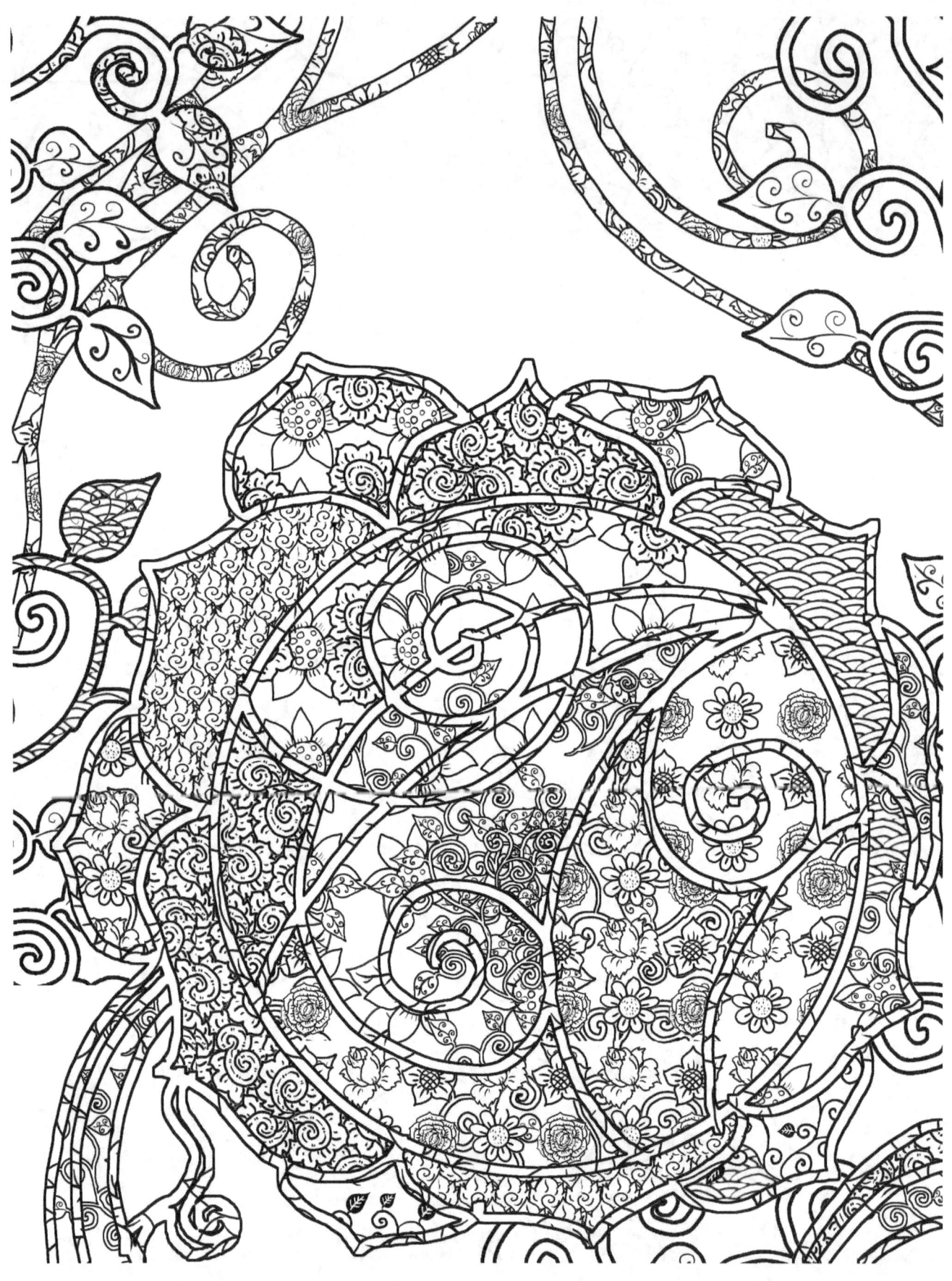

Bambang Wisudyantoro
cannonzhooter@gmail.com

Thank You !

www.ingramcontent.com/pod-product-compliance
Lightning Source LLC
Chambersburg PA
CBHW080531190526
45169CB00008B/3114